Light into Colour
Turner in the South West

Contents

St IVES

TATE

Published by Tate St Ives. Tour in partnership
with Plymouth City Art Gallery and Museum.
Exhibition supported by Tate St Ives' Members
and Tate Members. Edition 2000.

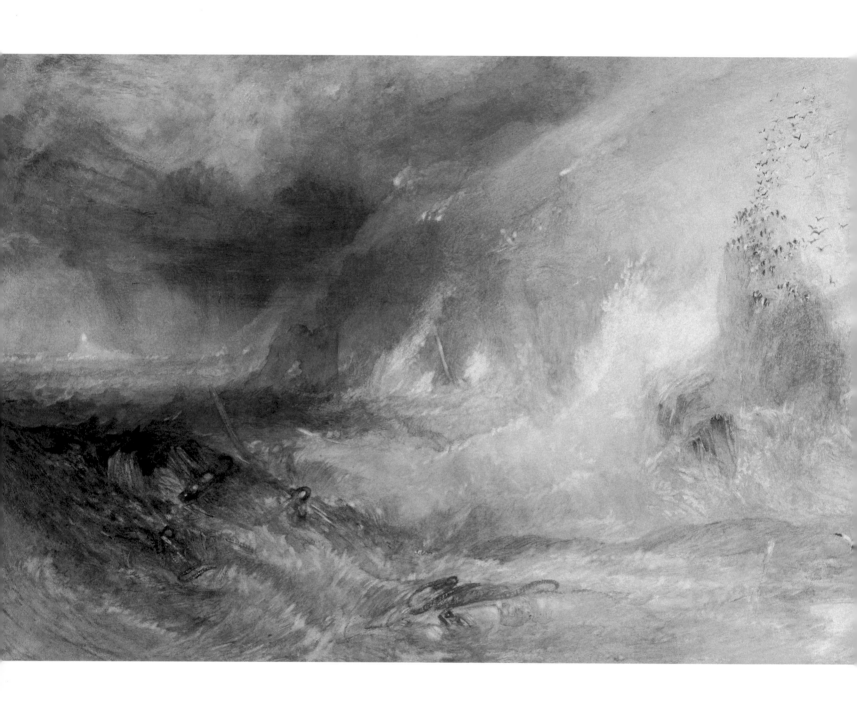

In appreciation
Susan Daniel-McElroy

The idea of showing Turner's works resulting from his tours of the South West was developed during a fortuitous conversation at the opening celebration of the work of David Nash and Mariele Neudecker at Tate St Ives in May 2004. In the space of roughly thirty minutes, the project was swiftly defined by a very experienced group of individuals. The curator was identified and the construct of the exhibition developed, illustrating to me the benefits of having such a range of people at Tate St Ives' exhibition previews.

In speaking with Sam Smiles, Turner expert based in the South West and curator of the exhibition, the idea to highlight Turner's early interest in atmospheric breaking forms and his use of light was an exciting prospect. The historic context of the St Ives Modernists and the particular qualities of light that attracted so many artists from the late nineteenth century onwards seemed a very relevant context for Turner.

We are delighted that this exhibition will subsequently be shown at Plymouth City Museum and Art Gallery, and are very grateful to our partners for their participation in this project, in particular Maureen Atrill, Keeper of Art. Many Tate colleagues, including Kate Parsons, Rosie Freemantle and Mary Bustin, have been involved in the exhibition process and we thank them for their vital support; in addition to the team at Tate St Ives who have facilitated the tour, Matthew McDonald, Norman Pollard and Sara Hughes. David Blayney Brown – Tate's Turner expert – has supported this project throughout and made many gentle interventions on our behalf for which we are very appreciative. Thanks are due to all the lenders to the show – too many to list here – for participating in the project and agreeing to be without their wonderful works for the best part of a year. Lastly, our warm thanks to Sam Smiles for curating a superb exhibition, which will enchant and engage many of our visitors.

Long Ship's Lighthouse, Land's End (not exhibited)
c.1834-5
Watercolour and gouache, scraped by the artist
28.6 x 44 cm
The J Paul Getty Museum, Los Angeles

'Devout Catholics go on pilgrimage to the shrine of a favourite saint… nor is the painter of any warmth of soul at rest till he has, in a like manner, visited Plympton, in Devonshire, where Sir Joshua Reynolds, the apostle of his art, was born' Allan Cunningham

Introduction
David Blayney Brown

'Devout Catholics go on pilgrimage to the shrine of a favourite saint… nor is the painter of any warmth of soul at rest till he has, in a like manner, visited Plympton, in Devonshire, where Sir Joshua Reynolds, the apostle of his art, was born'. Thus Allan Cunningham introduced his account of the painter David Wilkie's visit to Devonshire in 1809, accompanied by his friend Benjamin Robert Haydon, Devonshire-born himself, and it was typical of his style and attitudes that he treated Wilkie's trip – a holiday from over-work – as a tour of duty to a shrine of High Art. Visits to its holy places are duly described – the Plympton house where Reynolds was born, occupied by Haydon's schoolmaster, his school-room, various collections of Reynolds' portraits, and then 'as in courtesy bound', the sites of Haydon's 'birth and breeding'. Haydon, after all, was then expected to become the greatest history painter of his age, a worthy successor to Reynolds himself. But as Sam Smiles makes clear in this book, when Turner visited Devon and Cornwall, he did so as a painter of nature. And in his case, family piety would have been as important as

professional, as his father was a Devonshire man, from South Molton. Once Turner (always a master of myths and mystifications) even claimed he was too. Discussing West Country artists from Reynolds to Samuel Prout with Cyrus Redding on a boat on a Devon river in 1813, he said 'You may add me to the list' and added he had been born in Barnstaple.

Redding was with Turner during his Devon tour in 1813. His memoir of his friendship with Turner was liberally quoted by Turner's own first biographer, Walter Thornbury. It shows that despite their professional and temperamental differences, there were parallels between Wilkie's visit and Turner's. Both artists were taken up by the intelligentsia of Plymouth, including the family of another promising young artist – a pupil of Haydon's – Charles Eastlake. Like Wilkie, Turner visited Saltram and saw the pictures – though as a house guest rather than a tourist. But far from parading the ghost of Reynolds, his Plymouth friends embraced his naturalism, encouraging him in one of his rare campaigns of outdoor oil sketching. The series

Longships Lighthouse
c.1834
Watercolour
35.2 x 51.1 cm
Tate

of small oils on paper represented here are the main outcome of the 1813 visit, which took place in hot and golden weather exceptional even for what Redding described as 'this English Eden'. Turner also toured the West Country in 1811 and 1814, and possibly much earlier, as this book speculates. Perhaps Bristol, where he visited his father's friends the Narraways in 1791-2, was – or had been intended to be – his gateway to the West.

This exhibition surveys the outcome of these trips. Much is topographical, starting with the western views for the Cookes' *Picturesque Views on the Southern Coast of England*. But Turner's original plan to accompany his published images with his poetry underlines the ambition of his project, so much more than mere view-making. Turner's topography encompasses life as well as landscape and displays the nation to itself – its naval power, tested and proved in the Napoleonic Wars, its history and antiquities. Drunken sailors and easy women find their place. All is movement and flux. Great ships are decommissioned,

trees fall to build more. Life goes on. And Turner's palette moves with it. The exhibition shows us that it was changing, his interest in light and colour intensifying, well before the 1819 visit to Italy so often cited as the catalyst. Turner's *Crossing the Brook* (1815), his greatest painting of the West Country, is a masterpiece of atmospheric brilliance and, as its title implies, marks his coming of age as a painter. Exhibited in the year of Waterloo, it is his own victory over the great traditions of art – which have not been conquered but absorbed. It is a prospect, looking most of all to the South and to paintings by Claude, to which as Sam Smiles shows, the West was often compared. Thus Turner hints at the complexities of national identity, formed by acquired culture as much as by geography. Perhaps, after all, Turner was acknowledging his own 'apostle of his art' as he followed the Tamar toward Plymouth Sound. It is right that we should think of this in St Ives, whose artists reached out a century later to the Mediterranean and the Atlantic and touched the currents of international Modernism through its light, skies and sea.

Hulks on the Tamar
1812
Oil on canvas
89.2 x 120.2 cm
Tate
Courtesy of Petworth House

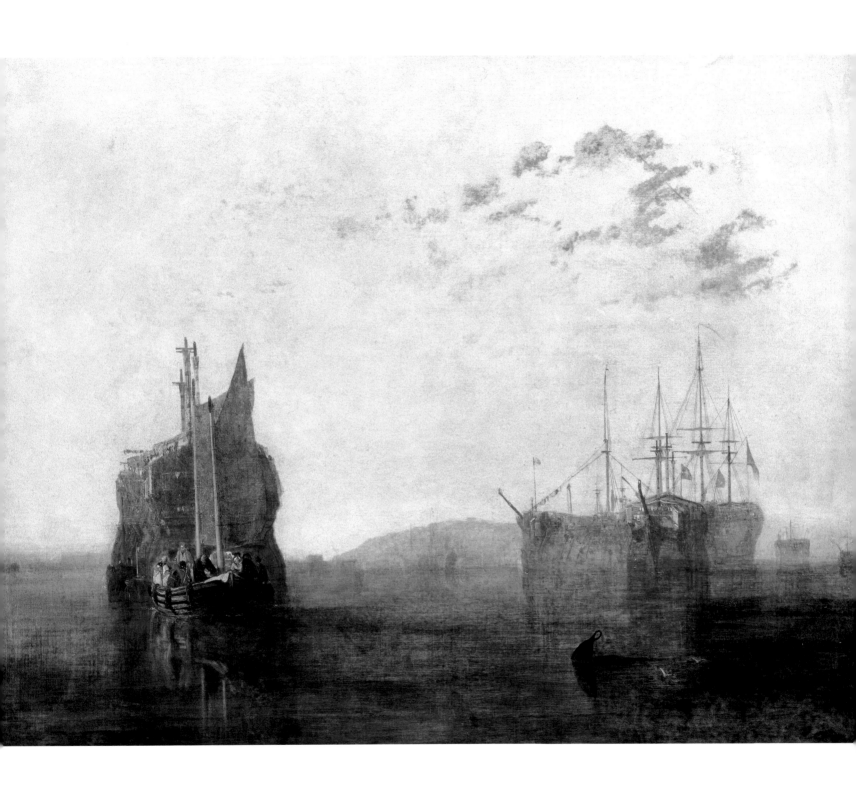

Light into Colour
Turner in the South West
Sam Smiles

Introduction

Turner's tours in the South West have never been the subject of an exhibition before. It is surprising that this is so, for Turner travelled extensively in the region in the 1810s and produced a significant body of work as a result: thirty finished watercolours of Devon and twenty of Cornwall, eight oils, at least fifteen oil sketches, some watercolour studies and numerous pencil drawings. The purpose of this exhibition is to say something about Turner's responses to Devon and Cornwall, to track his movements, to observe his reactions and to show a representative selection of his paintings.

Turner had travelled widely throughout Britain by the time he made his first tour of Devon and Cornwall in 1811. He already knew the picturesque scenes popular with tourists, from the tranquillity of the Thames valley to the grandeur of the Welsh mountains, and there was little in the West Country's terrain that was evidently superior to those landscapes. Indeed, much of what he depicted in Devon and Cornwall may be said simply to have offered a record of a tranquil countryside fringed with coastal settlements. But in one respect, as many subsequent artists have agreed, the region was distinguished: for the quality of its light. At the time of Turner's three tours, artists and amateurs promoted the south Devon and Cornish coasts

as almost Mediterranean in their appearance, comparable to the south of France, Italy or Portugal. Colours were deemed to be more intense, the light warmer and the sun more brilliant than it appeared further east and north.

It is tempting to say that if there was one artist working in early nineteenth-century Britain who could have made a response to the atmospheric qualities of the West Country it was Turner. But Turner's artistic response to light and colour is customarily believed to have received its biggest impetus from his initial visit to Italy in 1819, when the intensity of Mediterranean light was revealed to him for the first time. That experience helped him become the painter of his maturity, using colour as a poetic or expressive device. The artist who visited Devon and Cornwall in the early 1810s was fundamentally a naturalist painter, basing his art primarily on observation, and it would be misleading to interpret Turner's work in the West Country as somehow transcending the local scene to explore light and colour alone. Nevertheless, it is fair to say that Turner's comprehensive depiction of the Devon and Cornwall landscape took full measure of its atmospheric envelope, especially in the oil sketches he made around Plymouth in 1813.[1]

From various of his remarks recorded by eye witnesses, it seems that Turner shared the perception that the West Country could be distinguished from the rest of England. He said that the scenery of the Tamar valley 'hardly appeared to belong to this island', and described various details as 'worthy of Italy' and 'altogether Italian'.[2] Although Turner had not yet travelled through Italy, he was familiar with the landscape tradition inspired by Italian landscape, in particular the art of his great seventeenth-century predecessor Claude Lorraine (c.1604-82). Claude's achievement as a landscape painter was highly regarded by British artists and connoisseurs, many of them considering his paintings to set the standard for all who followed him. Claude had spent most of his working life in Italy, idealising the landscapes around Rome in oil paintings of Classical myth and history. Turner's comments about the 'Italian' appearance of the Tamar were most likely prompted by its reminding him of Claude's art. Yet for all his respect for ideal landscape, Turner was also a dedicated observer of actual nature. He would not have spoken about the Tamar in that way if the West Country scene had not offered something distinctive from his experiences elsewhere in Britain.

Coincidentally, in 1811 Turner delivered for the first time his course of lectures as Professor of Perspective at the Royal Academy. It is clear from various remarks he made in these talks that he was highly responsive to the opportunities offered by the British landscape and its changeable weather. Equally, he was keen to introduce students to the European landscape legacy, to demonstrate its seriousness as an art form. What comes through in these lectures is Turner's insistence that great landscape artists, like Claude, studied nature attentively but also worked creatively, using their powers of imagination to invent a landscape rather than merely copying one.

The finished watercolours and oil paintings deriving from Turner's West Country tours should be understood in this light; although topographically identifiable, they also offered Turner the means to move away from routine depictions of place to explore composition, light and colour. And because the finished watercolours, derived from his West Country tours, were produced over three decades (from the 1810s to the 1830s), we can follow developments in Turner's overall understanding and treatment of landscape in these years.

Background to the tours

Although the exhibits assembled here are primarily associated with the three tours Turner made to Devon and Cornwall in the 1810s, his only documented visits to the region, there are reasons to believe that he may have travelled west before then. His father had been born in South Molton, Devon, and two of his uncles lived in Exeter and Barnstaple. When Turner visited Dunster Castle, on Somerset's western border, probably in 1797, it is reasonable to suppose that he could have pushed on into Devon to visit his relatives.[3] Certainly, the pictorial possibilities of the West Country were in his mind at the close of the century. In two sketchbooks he was using in about 1798-99, Turner drew up a list of the most significant picturesque sites in Devon, Cornwall, Dorset and Somerset.[4] A few years later he was certainly planning to travel west. On 6 April 1805 Turner wrote to his Wiltshire patron Sir Richard Colt Hoare about the late delivery of some commissioned watercolours of Salisbury and its cathedral. Apologising for keeping Colt Hoare waiting, Turner promised him to complete the set by the end of the summer, adding: 'I wish I could say sooner; perhaps I may be able before I go to Devonshire, but even then I fear the Summer will be far advanced.'[5]

But if Turner did journey into Devon in the late 1790s and early 1800s he left no trace of it; there are no sketchbooks of that period in his career that can be linked to the region and no finished watercolours were produced either. The first documented visit to Devon and Cornwall dates from 1811 when he was employed to produce a series of topographical watercolours for *Picturesque Views on the Southern Coast of England*, a publication devised by the engraver and publisher William Bernard Cooke (1778-1855). Cooke and his younger brother, George, also an engraver, had already provided engravings for other publishers, but in the first decade of the nineteenth century they became entrepreneurs and publishers themselves, issuing a work on the scenery of the river Thames and promoting their own schemes.[6] Working with Turner was their ambition and the *Southern Coast* was the project they initiated to collaborate with him. It would be issued to subscribers in sixteen regular instalments over four years, to be bound into two volumes when completed. Each instalment would contain three engraved plates, two vignettes and a descriptive text. Turner was first contracted to produce 24 of the 48 watercolours required; in the event he contributed 40 designs. Although the first

engravings were issued to subscribers in 1814, mounting costs and arguments between Turner and the Cooke bothers led to the scheme being abandoned in 1826. Nineteen of Turner's designs for this series depict scenes in Devon and Cornwall, so constituting the most extensive repertoire of West Country landscapes in his oeuvre.

By 1811 Turner was well used to the production of topographical watercolours. Indeed, for some twenty years it had played a significant role in the establishment of his reputation. As we have seen, Sir Richard Colt Hoare commissioned him to make watercolour drawings of buildings in and around Salisbury between *c*.1796 and 1806, and Turner had gained his early esteem as a watercolour artist by producing similar images. His watercolours of the 1790s and early 1800s are typified by depictions of old bridges, ruined abbeys, castles, and the like, concentrating on the picturesque appeal of Britain's medieval legacy. But as Turner's career developed his attitude to topography changed; rather than concentrating on the architectural relics of the historic heritage he became increasingly interested in showing the way of life of those who lived near these picturesque sites. The people depicted in Turner's watercolours are not incidental details,

provided merely to add little spots of colour or to populate the image with token figures, but accurately observed inhabitants of actual locations. Their activities help guide the viewer to understand something about the trades carried on, the social mix of the community and, ultimately, the character of the place portrayed. Turner was doing this, moreover, with an increasingly sophisticated handling of the watercolour medium, allowing light and colour to make a more decisive contribution to the overall impact of the image. He was thus changing topography from a tame rendition of architectural and natural features into a dynamic exploration of place and people. When the Cookes commissioned him for the *Southern Coast* they knew precisely what they were about; they were aiming to secure the services of the artist who was revolutionising topography.

Topography in the Regency period

Although the *Southern Coast* was a commercial failure suffering from cost over-runs, not to mention the personal friction between artist and publisher which led to a total breakdown in relations after 1826, it is important to understand that the Cookes' proposal had at least the potential to succeed. When the *Southern Coast* was initiated in 1811 England was at war with Napoleonic France. The conflict severely restricted the opportunities for travellers to visit the continent, so encouraging domestic tourism in Britain and the production of topographical prints to satisfy that market. Moreover, by selecting the south coast of England for this series, the Cookes were calling attention to that part of the country most obviously affected by the defensive preparations against French attack. Even if victory at Trafalgar in 1805 had removed the fear of immediate invasion, the Channel coast still marked the place where any new threat would emerge. To depict its scenery, its historic buildings and its inhabitants going about their peaceful business was, in a way, to reinforce a sense of the nation's integrity and identity.

Of course, topographical series did not require the threat of conflict as an inducement for sales. Even after Napoleon's final defeat in 1815, with the threat of invasion lifted for good

and European tourism opening up again, the possibility of leisured consumers coming to know Britain for the first time through the medium of topographical publications needs to be remembered. Today, benefiting from cheap travel, television and multi-media on the web, we take for granted our ability to visit other places, whether actually or virtually. In Turner's time, most people, even the wealthy, knew very little of the look of the country as a whole. Although stage-coach times got progressively faster, horse-drawn travel was relatively slow (nearly twenty-four hours from London to Plymouth, for example) and away from the turn-pike roads it was very slow indeed. Devon was notorious for the poor repair of its roads with carriages often unable to move at more than walking pace. Cornwall was, of course, even more remote; although the route from London to Falmouth was in reasonable repair, very few casual travellers visited the county. In these circumstances, those who were curious about the British landscape, the ports, towns and villages, the remains of historic buildings and other memorable features could only have their curiosity satisfied by topographical prints.

What the Cookes were doing can therefore be seen as part of a more general trend; it is worth remembering that with respect to Devon

and Cornwall, some sixty illustrated topographical publications appeared between the 1800s and the 1820s. WB Cooke originally intended to add another venture to that tally with the *Rivers of Devon*. Turner was commissioned to produce at least six watercolours, starting work in 1815, but the proposed publication did not appear and the engravings were published separately or in other series in the 1820s and afterwards.[7] Cooke also commissioned Turner to contribute at least seventeen watercolours to his *Rivers of England* project, published 1823-5, including three engravings of scenes on the river Dart and one on the Okemont.

As the last engravings associated with the *Southern Coast* were being published, Turner was already at work on what is widely regarded as the most important topographical series he ever undertook. *Picturesque Views in England and Wales* was commissioned by the publisher Charles Heath. Between 1824 and 1836 Turner was required to produce a hundred watercolours for engraving, ninety-six of which were published between 1827 and 1838, thirteen of them depicting Devon and Cornwall. He did not need to travel to the West Country again, simply returning to the sketchbooks he had filled in the 1810s.[8]

St Mawes at the Pilchard Season
1812
Oil on canvas
91.1 x 120.6 cm
Tate

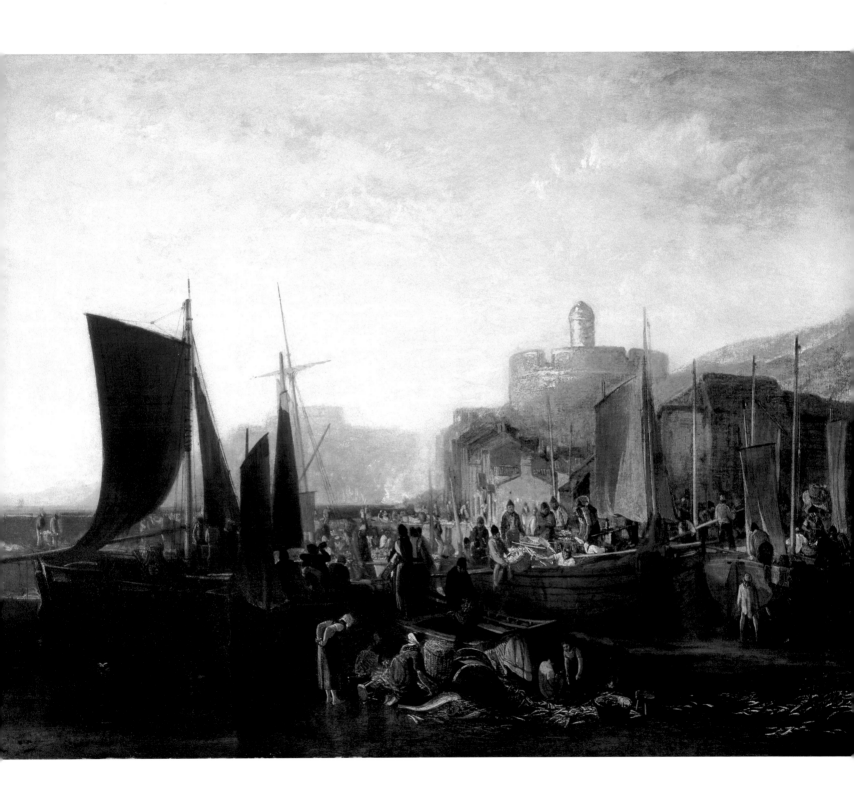

The artist at work

To make drawings suitable for these sorts of series Turner's characteristic procedure was to make a tour, usually in the summer or early autumn, recording his observations of landscape and notable architectural features in sketches made on the spot. Although he made colour sketches in the open air at the beginning of his career, by the 1810s he was increasingly reluctant to do so, contenting himself simply with drawing in the small sketchbooks he carried for that purpose. Drawing was faster, the equipment required could be easily carried and it allowed Turner to make numerous observations of the same location if he felt that to be necessary. These rapid notations were described by a witness of Turner at work in Devon as more like writing than drawing.[9] In addition to these cursory depictions Turner also made more elaborate and detailed drawings, but relatively few of these exist and it is reasonable to suppose that this was an infrequent procedure. He could afford to dispense with highly detailed memoranda of what he saw because his visual memory was so acute; years of training had disciplined his perception and his hand, such that what seems to us a highly abbreviated sketch contained within it everything he needed to recapture the scene. Given that over a decade might

separate a tour from Turner's production of a watercolour derived from it, his ability to recover a visual experience from these drawings is truly remarkable.

On return to London he would use what he had collected on tour as the basis for the finished watercolours. Using a sketchbook as a visual prompt, Turner would begin to work out a composition that satisfied two potentially contradictory requirements: pictorial coherence and topographical detail. As an artist he had to make the everyday into a memorable image and sometimes this required him to adjust what was found in nature. Turner's ambition was always to raise the status of landscape painting, even topographical painting, from a routine and mechanical copy of reality into a complex and creative response to nature. Rather than providing an exact visual description of a place, these watercolours distilled the experience of being there.

Between drawing and finished watercolour Turner experimented, using so-called 'colour beginnings' to block out the colour structure underlying the composition. To our eyes, these colour sketches look uncompromisingly radical, almost abstract, but their significance for Turner lay in working out how he would use colour to

organise the finished picture. It is precisely because these colour structures had been carefully planned that Turner could include such a volume of topographical information in the finished picture; held within a matrix of light and colour there is no possibility of these intimately observed details overwhelming the composition. Yet for all its artifice, and its independence from Turner's actual experiences on the spot, this use of light and colour is always atmospherically convincing.

Once completed, the paintings would be handed over to the engravers whose job it was to translate Turner's colour into black and white and his watercolour washes into skeins of engraved lines. Turner took a keen interest in the engraving process and the subtle use of tonal variations to produce the effect of light. As trial proofs were pulled he would 'touch' them with black and white chalk to indicate where adjustments needed to be made, as well as offering spoken or written advice to the engraver. As a result, Turner helped train a school of landscape engravers to an extraordinarily high standard of accomplishment.

Turner was well paid for the topographical work he produced but he also used his experience to prepare paintings independent of his

The three tours
1811

commissions. In the winter of 1811, he painted six oils of Devon and Cornwall subjects for exhibition the following year in his own gallery: *St Mawes at the Plichard Season, Saltash with the Water Ferry, The River Plym, Ivy Bridge Mill, Devonshire, Hulks on the Tamar* and *Teignmouth*, selling the two last-named to his patron, the Earl of Egremont. Such a concentrated burst of activity was not repeated, only one further oil being produced in the wake of the 1813 and 1814 trips to Devon: *Crossing the Brook*.[10] This ambitious painting, resulting from his work in the Tamar valley, is the masterpiece of Turner's work in Devon and Cornwall and, indeed, of his early development as an artist. Its deliberate emulation of Claude, its large size and the fact that he chose to exhibit it at the Royal Academy in 1815 indicate that Turner intended it as a demonstration of all he had come to understand about the depiction of landscape and atmosphere.

Turner left London in July 1811 and began his tour of the south coast at Poole, in Dorset, moving in a westerly direction along the south Dorset, Devon and Cornish coasts to Lands End and then travelling along the Bristol Channel until reaching Watchet in Somerset, where he turned inland to pick up the coach to London. The whole trip took about eight weeks. Although Turner returned twice to Devon, and explored both banks of the Tamar, this was his only extensive tour of Cornwall and all the watercolours of Cornish scenes completed in the subsequent decades (the last being *Mount St Michael, Cornwall, c.*1836) were based on his experiences in the summer of 1811.

Turner's progress round the coast was rapid and he probably had very little time to make acquaintances in any of the spots he visited. At Plymouth, however, the ground had been prepared for him. The Plymouth-born painter Charles Eastlake already knew Turner and wrote from London to his father in July, asking him to make Turner welcome:

'What he wants is to go on board some large ship, & I daresay George [Eastlake's brother] will be very happy to take him on board the Salvadore, and perhaps into the Dockyard, &c. He is the first landscape painter now in the world, and before he dies will perhaps be the greatest the world ever produced. I hope all at Plymouth will be attentive to him, as it is really an honour to be acquainted with him… I say all this because you may never have heard of him – if you have it is unnecessary.'[11]

Eastlake's advice about the Dockyard demonstrates just how inclusive Turner's notion of the picturesque was. The fact that his watercolours contain so much detailed observation on the antiquities and trades of each location is confirmed by the poetry he wrote in one of the sketchbooks used on the tour, outlining the history and economic affairs of the places he visited.[12] Turner had volunteered to provide the letterpress to the *Southern Coast* and submitted these verses to Cooke for that purpose.[13] The writer and satirist William Combe was asked to edit them but it was recommended instead that he 'improve' them to make them fit for publication, at which point Turner withdrew his offer and Combe provided the text himself.[14]

Crossing the Brook (due to fragility, not exhibited)
*c.*1815
Oil on canvas
193 x 165.1 cm
Tate

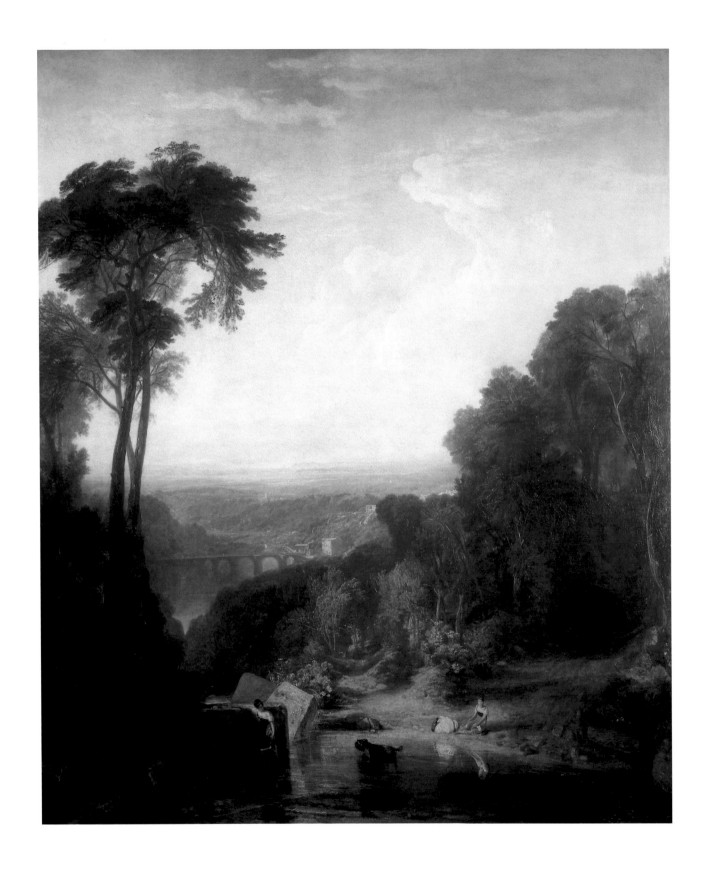

1813

Turner returned to Devon in the summer of 1813 and seems to have largely contented himself with working in the vicinity of Plymouth and exploring the lower reaches of the rivers Plym, Tamar and Tavey. The hospitality he had been shown by the Eastlakes in 1811 was now extended, and two eye-witness accounts record the ways in which Turner was made thoroughly welcome by the local artists and intelligentsia, accompanying him on sketching expeditions, a boat trip to Burgh Island, a musical recital at Saltram House and various picnics for the artist and his companions.[15] One of the promoters of cultural life at Plymouth was Henry Woollcombe, who had founded the Plymouth Institution in 1812 to advance knowledge of the arts and sciences. He recorded meeting Turner in late August:

'Dined at Wm. Eastlake's met a pleasant party, amongst them Mr. Turner the Artist whose works I have so much admired he is brought hither by the beautifull scenery of our neighbourhood, there is a chance of his occasionally residing amongst us, I heartily wish this may take place, as it is always desirable to attract talent around us, where it is accompanied by respectability.'[16]

The most significant feature of this trip was Turner's return to oil sketching from nature. He had made his first plein-air oil sketches in Kent c.1799-1801 and produced an extensive series of studies on the Thames and the Wey c.1805 but had not attempted any further sketching from nature since then. The Plymouth landscape painter, A.B. Johns, encouraged Turner to return to it, as witnessed by Charles Eastlake:

'After [Turner] returned to Plymouth, in the neighbourhood of which he remained some weeks, Mr. Johns fitted up a small portable painting-box, containing some prepared paper for oil sketches, as well as the other necessary materials. When Turner halted at a scene and seemed inclined to sketch it, Johns produced the inviting box, and the great artist, finding everything ready to his hand, immediately began to work. As he sometimes wanted assistance in the use of the box, the presence of Johns was indispensable, and after a few days he made his oil sketches freely in our presence.'[17]

Unfortunately, the preparation of the paper was defective and although Turner made many such oil sketches, only just over a dozen have survived.[18]

These oil sketches are of particular interest not only because of Eastlake's account of their production but also because they show Turner's direct response to that 'Italianate' landscape around Plymouth. Those studies made under clear skies, and relying on the opposition between blue and yellow for their impact, seem to be concerned with capturing something of the warmth and intensity of light that was presumed to be so typical of this environment.[19]

Turner was normally extremely reluctant to let others observe him sketching but at Plymouth in 1813 he seems to have lowered his guard. Eye-witness accounts provided by Eastlake, Woollcombe and the journalist Cyrus Redding all concur with Turner's openness and generosity, allowing his Plymouth acquaintances to examine his oil studies. Woollcombe was shown a selection of sketches when he breakfasted with Turner[20] and Redding remembered how at a picnic on Mount Edgcumbe Turner 'showed the ladies some of his sketches in oil, which he had brought with him, perhaps to verify them.'[21] Eastlake recalled that 'Turner seemed pleased when the rapidity with which these sketches were done was talked of; for, departing from his habitual reserve in the instance of his pencil sketches, he made no difficulty of showing them. On one occasion, when… the day's work was shown, he himself remarked that one of the sketches (and perhaps the best) was done in less than half an hour.'[22]

1814

Henry Woollcombe visited Turner in London in April 1814 and reported to his sister: '[Turner] is a warm admirer of the scenery of Devonshire and proposes another visit in the present year.'[23] AB Johns also visited him the following month and perhaps it was at this meeting that he arranged for Turner to stay with him in Plymouth a few weeks later.[24] Turner's trip to Devon must have taken place in late summer 1814 for the only direct reference to it comes in a letter he wrote to Johns some time in early October.

'…Give my respects to Mrs Johns. Be so good as to thank her for me "say that I got rid of my cold by catching a greater one, at Dartmouth being obliged to land from the boat half drownded with the spray as the gale compeled the boatmen to give up half way down the Dart from Totnes.'[25]

The sketchbook known as 'Devon Rivers No. 2' contains drawings on the river Dart between Totnes and Dartmouth which may, perhaps, have been made on this boat trip. For the rest of his time in Devon Turner probably stayed with Johns, sketching in and around Plymouth, as he had the year before.

As far as is known, this was Turner's last trip to the West Country. His relations with Johns and his circle remained very cordial over the next few years and he lent two oil paintings to the first exhibition of the Plymouth Institution in 1815 to help make it a success. But he had taken from Devon and Cornwall what he needed and as the years passed his relations with his Plymouth friends dwindled.[26] His work in this region, for all its brevity as a moment in Turner's long career, stands at the threshold of his mature development. Within a decade he would have transformed the landscape tradition, exploring light and colour as the basis of perception. With hindsight, perhaps, we can see Turner's work of the early 1810s as laying the foundations for that achievement.

The Plym Estuary, looking North
1813
Oil on prepared paper
15.5 x 25.6 cm
Tate

The Plym Estuary from Boringdon Park
1813
Oil on prepared paper
24.5 x 30.5 cm
Tate

Hamoaze from St John, Cornwall
1813
Oil on prepared paper
16.4 x 25.7 cm
Tate

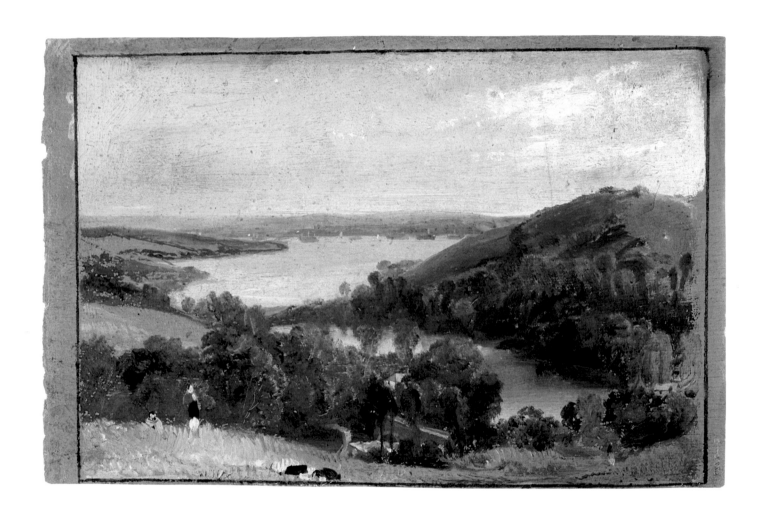

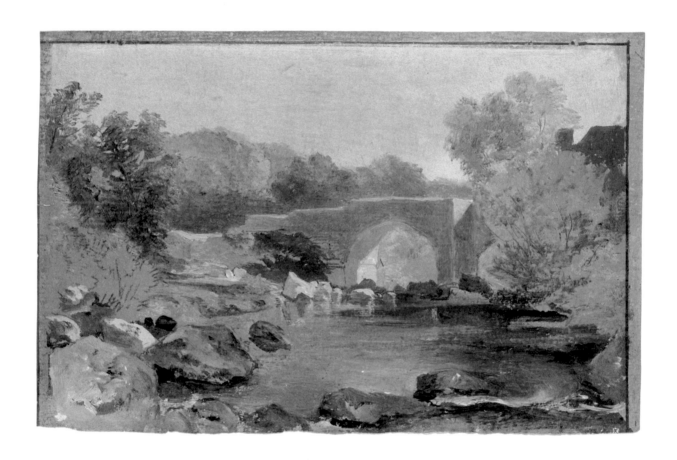

Devonshire Bridge with Cottage
1813
Oil on prepared paper
15.5 x 24.3 cm
Tate

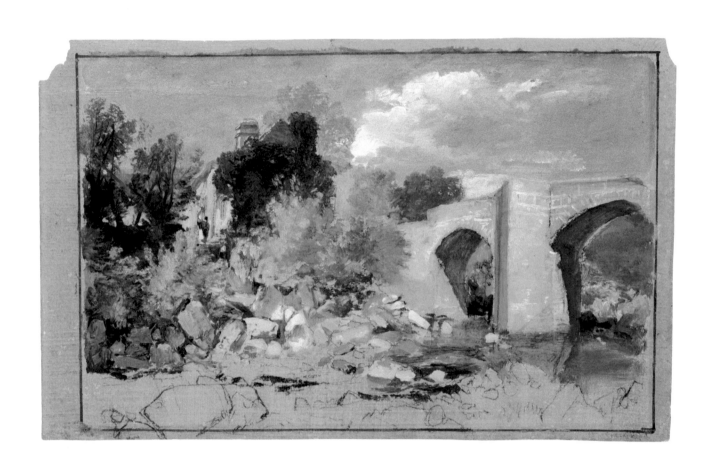

A Bridge with a Cottage and Trees beyond
1813
Oil and chalk on prepared paper
15.9 x 26.1 cm
Tate

Ivy Bridge
*c.*1813
Watercolour
28 x 40.8 cm
Tate

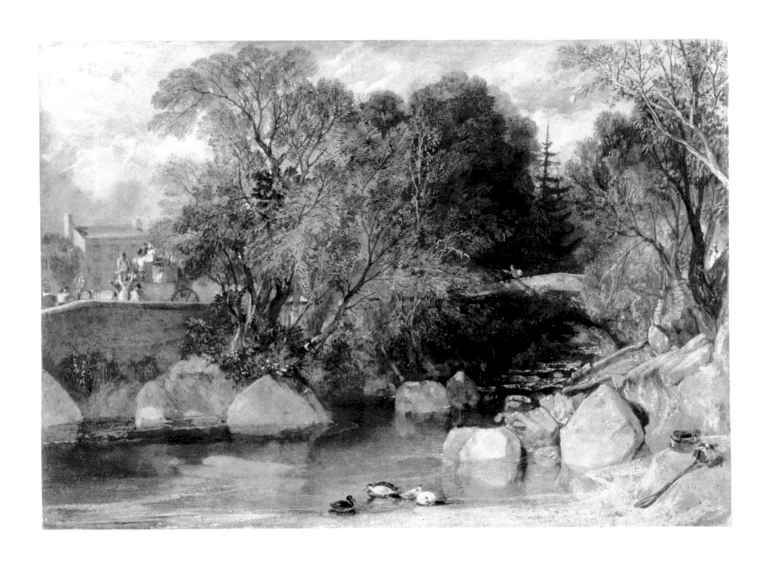

Shaugh Bridge, near Plymouth
1813
Oil on prepared paper
15.8 x 26.6 cm
Tate

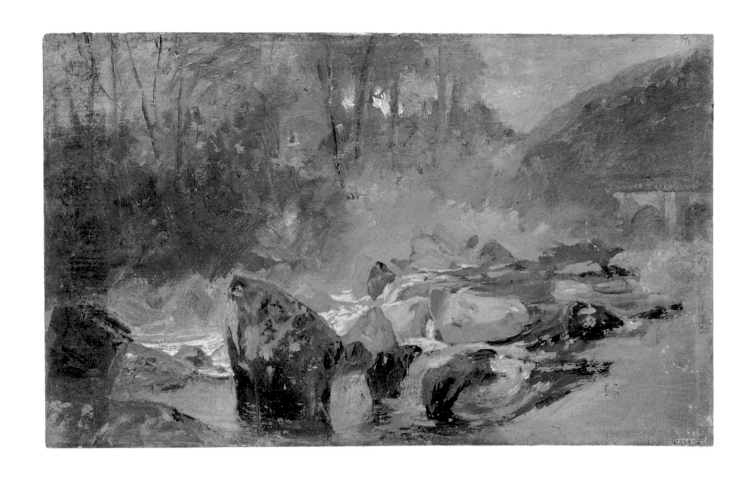

Plymouth with Mount Batten
*c.*1816
Watercolour
14.6 x 23.5 cm
Victoria and Albert Museum

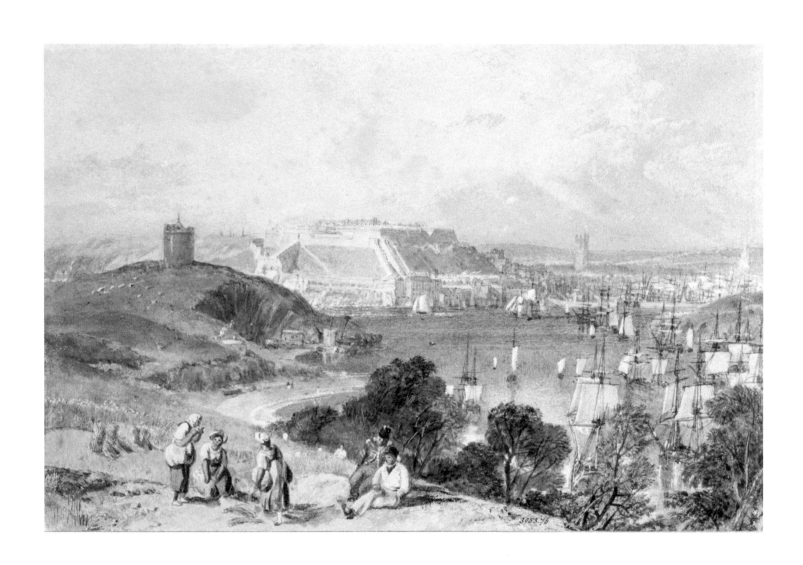

Plymouth
*c.*1830
Watercolour
28 x 41.2 cm
Victoria and Albert Museum

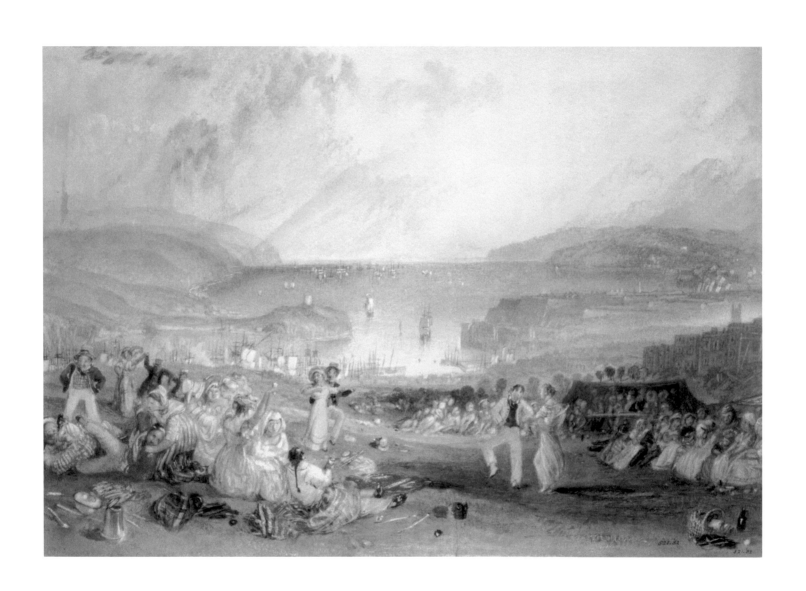

Plymouth*
*c.*1825
Watercolour
16 x 24.5 cm
Courtesy Calouste Gulbenkian Museum, Lisbon
Photo: Margarida Ramalho

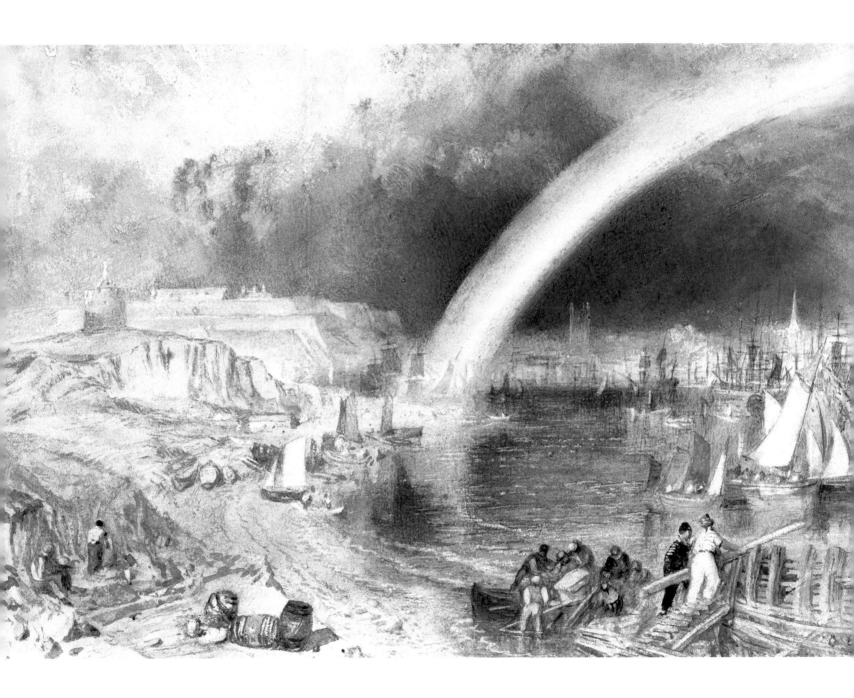

Plymouth with Mount Batten
*c.*1825
Watercolour
30.3 x 48.7 cm
Tate

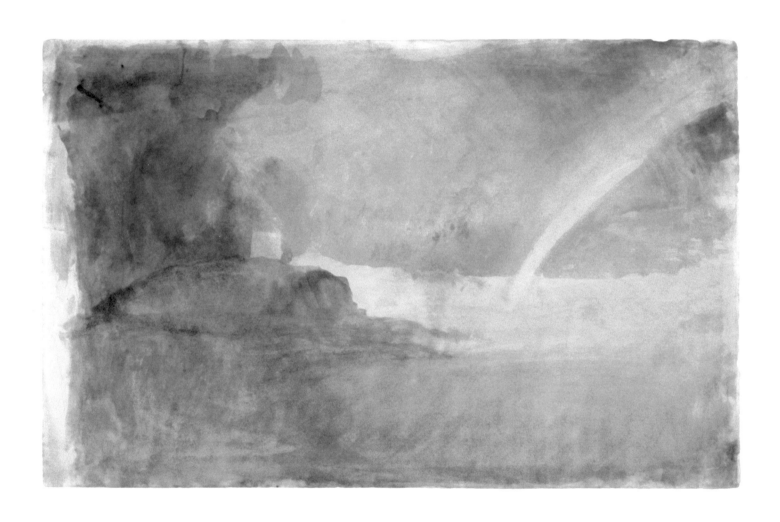

Mount St Michael, Cornwall
*c.*1836
Watercolour
30.5 x 43.9 cm
University of Liverpool Art Gallery and Collections

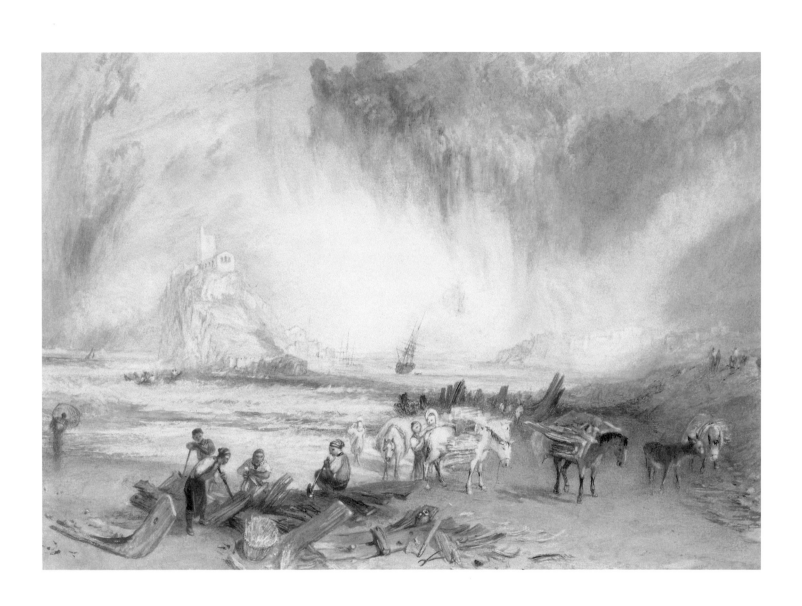

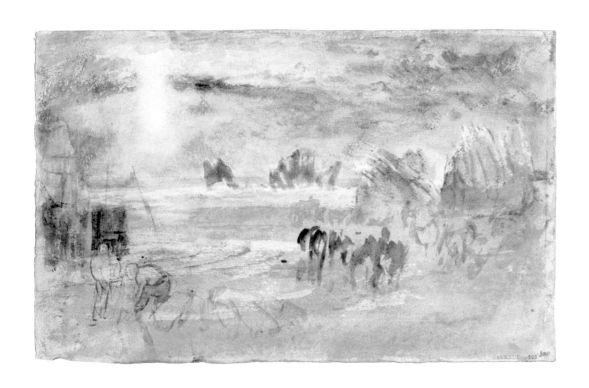

'Sand landing' by Moonlight
c.1823
Watercolour
14.9 x 24.2 cm
Tate

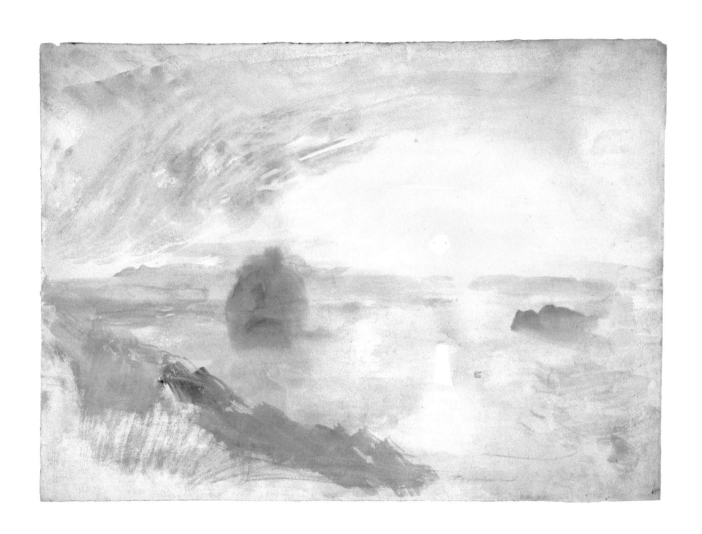

St Michael's Mount
*c.*1828
Watercolour
34.8 x 48.9 cm
Tate

Barnstaple Bridge at Sunset
*c.*1813
Watercolour
21.5 x 33.9 cm
Tate

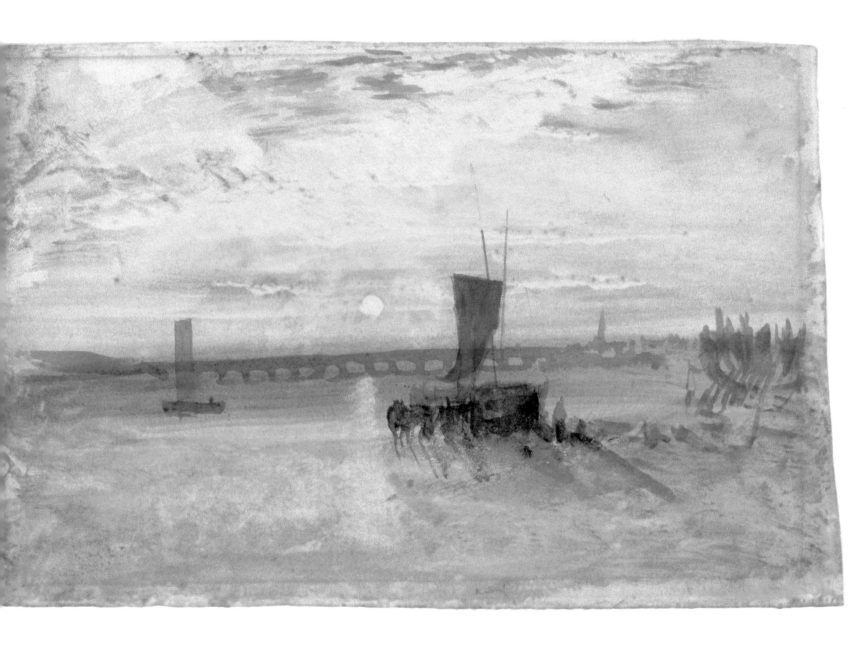

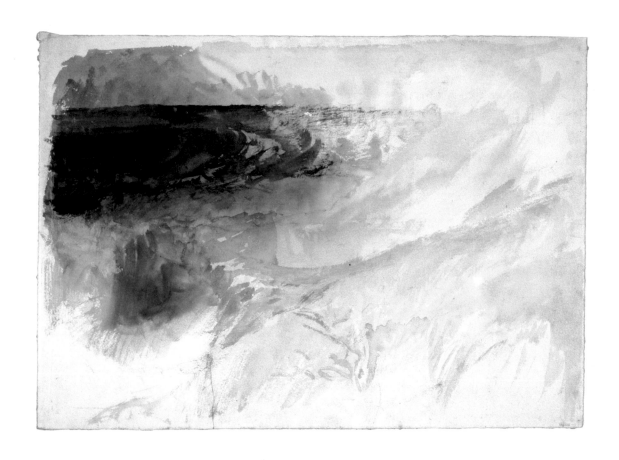

Lands End
*c.*1834
Watercolour
35.6 x 31 cm
Tate

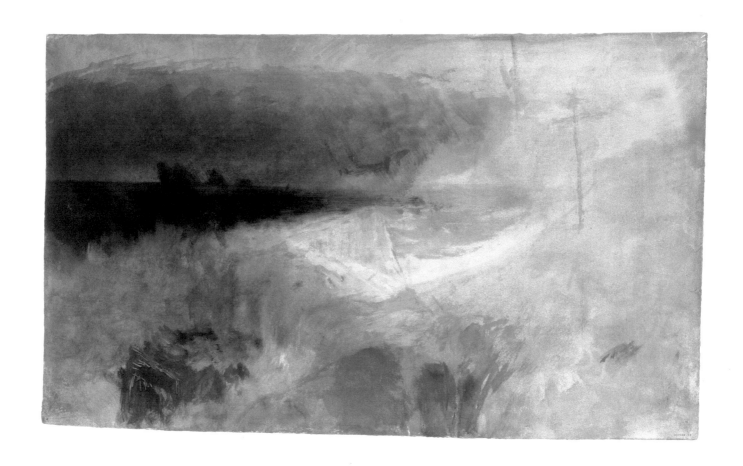

Lands End
*c.*1834
Watercolour
38 x 61.3 cm
Tate

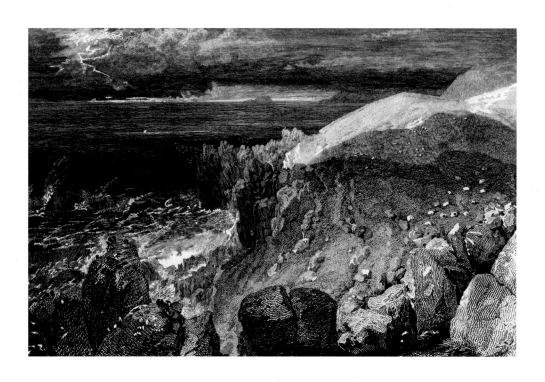

Engraved from a drawing by JMW Turner
Lands End, Cornwall
1814
Line engraving on copper
14.2 x 22 cm
Tate

Footnotes

1 It is perhaps more than coincidence that a sketchbook used on the 1811 tour for Turner's poetry includes lines describing 'the gay Occident of Saffron hue/In tendrest medium of distant blue.' See TB CXXIII *Devonshire Coast No. 1* (1811), f.164 v; transcribed in Andrew Wilton and Rosalind Mallord Turner *Painting and Poetry: Turner's Verse Book and his Work of 1804-1812*, London: Tate Gallery Publications, 1990, p.175.

2 Cyrus Redding *Past Celebrities whom I have Known*, London, 1856, p.53 and *The Late JMW Turner*, *Fraser's Magazine*, XLV, February 1853, p.154.

3 An engraving by Samuel Rawle, after a lost watercolour by Turner of Dunster Castle, was published in *The European Magazine* on 1 March 1798. Rawle produced two further engravings of Dunster Castle, published as separate plates on 1 May 1800. They were dedicated to the MP J Frownes Luttrell. One of the original watercolours has been identified, the other is untraced.

4 TB XL *Dinevor Castle* sketchbook (*c*.1798) flyleaf and TB XLVI *Dolbadarn* Sketchbook (*c*.1799) f.119a. These lists were copied from the antiquarian James Moore's *A List of the Principal Castles and Monasteries In Great Britain*, London, 1798.

5 John Gage *Collected Correspondence of JMW Turner*, Oxford University Press, 1980, p.25.

6 WB Cooke *The Thames, or graphic illustrations of seats, villas, public buildings, and picturesque scenery on the banks of that noble river*, London, 1811.

7 Four subjects were engraved for the *Rivers of Devon* project: *Plymouth Citadel*, *Plymouth Sound*, *Ivy Bridge*, *Dartmoor: the source of the Tamar and the Torridge*. The watercolour of the *Eddystone Lighthouse* was issued as part of another series entitled *Marine Views*. A further watercolour, *Sunshine on the Tamar*, is associated with the *Rivers of Devon* scheme but was not engraved. It was made into a chromolithograph in 1855.

8 Further West Country scenes were engraved in other series. Thomas Lupton, who had worked as an engraver for the Cooke brothers, commissioned Turner to make twenty-five watercolours for his publication *The Harbours of England*, but a serious quarrel between artist and engraver brought the project to a close with only thirteen designs completed. Four of Turner's designs were of harbours in Devon and Cornwall (*Sidmouth*, *Falmouth* and two views of *Plymouth*). Six prints were published 1826-8 as the *Ports of England* and then reissued, with the six unfinished plates, in 1856 as *Harbours of England*.

9 Cyrus Redding, cited in Walter Thornbury *The Life of JMW Turner, R.A.*, (second edition) London, 1877, p.144.

10 Turner's picture of *The Prince of Orange, William III, embarked from Holland, and landed at Torbay, November 4th, 1688, after a Stormy Passage* (1832) has no topographical features and was painted to remind viewers of constitutional issues at the time of the Great Reform Bill. In 1838 he exhibited the oil painting *St Michael's Mount, Cornwall*, based on the watercolour engraved in 1814 for the *Southern Coast*.

11 Sir CL Eastlake *Contributions to the Literature of the Fine Arts* (second series), London, 1870, p.23.

12 TB CXXIII *Devonshire Coast No. 1* (1811). The verses are transcribed in Andrew Wilton and Rosalind Mallord Turner *Painting and Poetry: Turner's Verse Book and his Work of 1804-1812*, London: Tate Gallery Publications, 1990, pp.170-6.

13 The task of supplying the text had originally been offered to the engraver and critic John Landseer, who had declined the commission, as it would have required him to tour and research the area more thoroughly than he had time to do.

14 Combe died in 1823 and Mrs Barbara Hofland completed the task.

15 Charles Eastlake related his memories to Walter Thornbury in his biography *The Life of JMW Turner, R.A.*, (second edition) London, 1877, pp.152-3. Thornbury (pp.142-52) also drew on the testimony of Cyrus Redding, a local journalist, who recorded his recollections in three versions: *The Late JMW Turner, Fraser's Magazine*, XLV, 1852, pp.150-6; *Past Celebrities whom I have Known*, London, 1856, pp.45-74; and *Fifty Years' Recollections, Literary and Personal*, London, 1858, pp.198-206.

16 *The Diary of Henry Woollcombe*, 27 August 1813, West Devon Record Office, 710/394. The Eastlake mentioned is William Eastlake, the father of Turner's colleague Charles Eastlake.

17 Walter Thornbury *The Life of JMW Turner, R.A.*, London, 1877, p.153

18 'When the executors were examining [Turner's] boxes after his death, they suddenly came upon several oil sketches. "Now", said Sir Charles Eastlake, "we shall find many more of these, for I remember being with Turner once in Devonshire, when he made sketches in oil." But no more were found.' Walter Thornbury, *The Life of JMW Turner, R.A.*, London, 1877, p.93.

19 It is perhaps worth noting that one of the sketchbooks used on these tours include recipes for a variety of yellow pigments and a note on cobalt blue.

20 The Diary of Henry Woollcombe, West Devon Record Office, 710/394, entry for 1 September, 1813: 'Breakfasted with Mr. Turner... had some lively and interesting conversation, saw all his sketches, with which I was well pleased. Mr. Turner is highly pleased with our neighbourhood.'

Footnotes continued

21 Walter Thornbury *The Life of JMW Turner, R.A.*, London, 1877, p.155.

22 Walter Thornbury *The Life of JMW Turner, R.A.*, London, 1877, p.153.

23 West Devon Record Office, 710/520. The letter is undated but Woollcombe's diary records a visit to Turner's studio on 13 April, 1814 (West Devon Record Office, 710/394).

24 Letter from Johns to his wife, dated 4 May 1814, City of Hamilton Art Gallery, Victoria, Australia.

25 See John Gage *Collected Correspondence of JMW Turner*, Oxford: Oxford University Press, 1980, letter no. 52, pp.57-9. For the dating of this letter and a discussion of the 1814 tour see Sam Smiles *Turner in Devon: some additional information concerning his visits in the 1810s, Turner Studies*, Summer 1987, vol. 7, no. 1, pp.11-14.

26 Johns was in contact with Turner until at least 1821, but seems to have lost all sympathy for the artist by the mid-1820s and stopped all communication when an engraving of his picture *Sunrise, or the Shepherd* was misattributed to Turner. See Sam Smiles *Turner in Devon: some additional information concerning his visits in the 1810s, Turner Studies*, Summer 1987, vol. 7, no. 1, pp.11-14.

Bibliography

Brown, David Blayney *Oil Sketches from Nature: Turner and his Contemporaries*, London: Tate Gallery 1991

Butlin, Martin and Joll, Evelyn *The Paintings of JMW Turner* (revised edition) New Haven and London: Yale University Press, 1984

Eastlake, Sir CL *Contributions to the Literature of the Fine Arts* (second series), London, 1870

Faigan, Julian *Ambrose Bowden Johns, Family and Friends*, City of Hamilton Art Gallery, 1979

Gage, John *Collected Correspondence of JMW Turner*, Oxford: Oxford University Press, 1980

Redding, Cyrus *The Late JMW Turner, Fraser's Magazine*, XLV, 1852, pp.150-6

Redding, Cyrus *Past Celebrities whom I have Known*, London, 1856

Redding, Cyrus *Fifty Years' Recollections, Literary and Personal*, London, 1858

Shanes, Eric *Turner's England*, London: Cassell, 1990

Shanes, Eric *Turner's Watercolour Explorations 1810-1842*, London: Tate Gallery 1997

Smiles, Sam *Turner in the West Country – from topography to idealisation* in JC Eade (ed.) *Projecting the Landscape*, Canberra: Australian National University, 1987

Smiles, Sam *Turner in Devon: some additional information concerning his visits in the 1810s, Turner Studies*, Summer 1987, vol. 7, no. 1, pp.11-14

Smiles, Sam *Picture Note: St Mawes, Turner Studies*, vol. 8, no. 1, Summer 1988, pp.53-7

Smiles, Sam *The Devonshire Oil Sketches, Turner Studies*, vol. 9, no. 1, Summer 1989, pp.10-25

Smiles, Sam and Pidgley, Michael *The Perfection of England: Artist Visitors to Devon c.1750-1870*, Exeter: Royal Albert Memorial Museum, 1995

Thornbury, Walter *The Life of JMW Turner, R.A.*, (second edition) London, 1877

Wilton, Andrew and Turner, Rosalind Mallord *Painting and Poetry: Turner's Verse Book and his Work of 1804-1812*, London: Tate Gallery, 1990

JMW Turner, Key dates

1775
Joseph Mallord William Turner, born in Covent Garden, London to William Turner, barber and wig-maker and his wife, Mary Marshall.

1787
First signed and dated drawing produced.

1789
Works as an architectural draughtsman for Thomas Hardwick and Thomas Malton; admitted as a student of the Royal Academy Schools.

1791
Exhibits at the Royal Academy; stays with the Narraway family, friends of his father, at Bristol and from there tours to Malmesbury and Bath.

1793
Awarded Great Silver Pallet by the Society of Arts for a landscape drawing.

1794
Tours the Midlands and North Wales; takes pupils as drawing master.

1795
Tours South Wales and then the Isle of Wight.

1796
Exhibits his first oil painting at the Royal Academy, *Fishermen at Sea*.

1797
Turner's first extensive tour of the North of England and the Lakes.

1798
Tours Kent and Wales.

1799
Elected an Associate of the Royal Academy.

1800
Turner's mother committed to the Bethlehem Hospital for the insane.

1801
Tours Scotland returning via Chester and the Lake District.

1802
Elected a full member of the Royal Academy. First Continental tour to France and Switzerland (July-October); spends three weeks in Paris and studies paintings in the Louvre.

1803
Serves on Academy Council and Hanging Committee for first time. Sir George Beaumont begins to criticise Turner's lack of finish.

1804
Turner's mother dies.

1805
Staying at Sion Ferry House, Isleworth, makes Thames oil sketches.

1807
Elected Professor of Perspective at the Royal Academy.

1811
Delivers the first series of six lectures as Professor of Perspective. Spends summer in the West Country, on commission for *Picturesque Views on the Southern Coast of England*.

1812
Begins building self-designed home, Sandycombe Lodge at Twickenham.

1813
Summer visit to Plymouth and environs.

1814
Summer visit to Devon.

1817
Turner's second continental tour. Visits Belgium, Holland and the Rhineland, including a tour of the battlefield at Waterloo. Will visit Europe most years until 1845.

1819
Turner's first visit to Italy, which lasts six months.

1820
Returns from Italy by end of January. Enlarges Queen Anne Street residence, including building new picture gallery.

1823
First *Rivers of England* engravings published.

1825
Begins work on commission for 120 watercolours to be engraved as *Picturesque Views in England and Wales*.

1826
First *Ports of England* engravings published.

1828
Last series of perspective lectures given; shares house with Charles Eastlake in Rome.

1829
Death of Turner's father; draws up first will.

1837
Royal Academy relocated to National Gallery, Trafalgar Square. Turner resigns his post as Professor of Perspective.

1838
Last plates published for *Picturesque Views in England and Wales*.

1850
Exhibits last four pictures at the Royal Academy

1851
Turner dies 19 December, in Chelsea. His body is buried in St Paul's Cathedral.

List of works

Oil Paintings

St Mawes at the Pilchard Season 1812
Oil on canvas, 91.1 x 120.6 cm
Tate, Bequeathed by the artist in 1856
N00484

Hulks on the Tamar 1812
Oil on canvas, 89.2 x 120.2 cm
Tate, Courtesy of Petworth House
T03881

Oil Sketches

Plympton 1813
Oil on prepared paper, 14.8 x 22.5 cm
Tate, Bequeathed by artist in 1856
D09208 / CXXX B

Hamoaze from St John, Cornwall 1813
Oil on prepared paper, 16.4 x 25.7 cm
Tate, Bequeathed by artist in 1856
D09209 / CXXX C

A Quarry 1813
Oil on prepared paper, 14.4 x 25.7 cm
Tate, Bequeathed by artist in 1856
D09210 / CXXX D

The Plym Estuary from Boringdon Park 1813
Oil on prepared paper, 24.5 x 30.5 cm
Tate, Bequeathed by artist in 1856
D09211 / CXXX E

A Bridge with a Cottage and Trees beyond 1813
Oil and chalk on prepared paper, 15.9 x 26.1 cm
Tate, Bequeathed by artist in 1856
D09212 / CXXX F

Shaugh Bridge, near Plymouth 1813
Oil on prepared paper, 15.8 x 26.6 cm
Tate, Bequeathed by artist in 1856
D09215 / CXXX I

On the Plym Estuary, near Crabtree 1813
Oil and chalk on prepared paper, 15.8 x 25.7 cm
Tate, Bequeathed by artist in 1856
D09216 / CXXX J

Devonshire Bridge with Cottage 1813
Oil on prepared paper, 15.5 x 24.3 cm
Tate, Bequeathed by artist in 1856
D09217 / CXXX K

The Plym Estuary, looking North 1813
Oil on prepared paper, 15.5 x 25.6 cm
Tate, Bequeathed by artist in 1856
D40028 / CXXX L

*Distant View of Plymouth** c.1813
Oil on prepared paper, 15 x 23.4 cm
Private collection
X13880

Watercolours

Ivy Bridge c.1813
Watercolour, 28 x 40.8 cm
Tate, Bequeathed by artist in 1856
D18157 / CCVIII X

Plymouth with Mount Batten c.1816
Watercolour, 14.6 x 23.5 cm
Victoria and Albert Museum
X12694

Plymouth c.1830
Watercolour, 28 x 41.2 cm
Victoria and Albert Museum
X12695

River Tavey/Sunshine on the Tamar c.1813
Watercolour, 21.7 x 33.7 cm
Ashmolean Museum, Oxford; Ruskin Collection
X12696

Dartmouth c.1824
Watercolour, 15.7 x 22.6 cm
Tate, Bequeathed by artist in 1856
D18136 / CCVIII C

Okehampton c.1824
Watercolour, 16.3 x 22.9 cm
Tate, Bequeathed by artist in 1856
D18138 / CCVIII E

*St Mawes, Cornwall** c.1823
Watercolour, 14.2 x 21.7 cm
Yale Center for British Art,
Paul Mellon Collection
X12702

Boscastle, Cornwall c.1824
Watercolour, 14.1 x 23 cm
Ashmolean Museum, Oxford
Presented by John Ruskin in 1861
X12697

Mount St Michael, Cornwall c.1836
Watercolour, 30.5 x 43.9 cm
University of Liverpool Art Gallery
and Collections
X12699

*Plymouth** c.1825
Watercolour, 16 x 24.5 cm
Fundação Calouste Gulbenkian, Lisbon
X12700

*Entrance to Fowey Harbour, Cornwall** c.1827
Watercolour, 28.2 x 39.1 cm
Private collection
X13879

* showing at Tate St Ives only

Colour Beginnings

*Barnstaple Bridge at Sunset c.*1813
Watercolour, 21.5 x 33.9 cm
Tate, Bequeathed by artist in 1856
D25443 / CCLXIII 320

*St Michael's Mount c.*1828
Watercolour, 34.8 x 48.9 cm
Tate, Bequeathed by artist in 1856
D25187 / CCLXIII 65

*Longships Lighthouse c.*1834
Watercolour, 35.2 x 51.1 cm
Tate, Bequeathed by artist in 1856
D25165 / CCLXIII 43

*Lands End c.*1834
Watercolour, 35.6 x 31 cm
Tate, Bequeathed by artist in 1856
D25129 / CCLXIII 7

*Lands End c.*1834
Watercolour, 38 x 61.3 cm
Tate, Bequeathed by artist in 1856
D36324 / CCCLXV b33

*'Sand landing' by Moonlight c.*1823
Watercolour, 14.9 x 24.2 cm
Tate, Bequeathed by artist in 1856
D25423 / CCLXIII 300

*Plymouth with Mount Batten c.*1825
Watercolour, 30.3 x 48.7 cm
Tate, Bequeathed by artist in 1856
D25272/CCLXIII 150

Engraving

Lands End, Cornwall 1814
Line engraving on copper, 14.2 x 22 cm
Tate, Purchased 1986
T04374

Sketchbooks

Ivy Bridge to Penzance 1811
16.6 x 20.8 cm
Tate, Bequeathed by artist in 1856
D08865-8939, D04815-17 / CXXV 1

Cornwall and Devon 1811
Tate, Bequeathed by artist in 1856
D08941-2, D41275-373 / CXXV 50 or CXXV A

*Plymouth, Hamoaze c.*1812-3
15.8 x 9.3 cm
Tate, Bequeathed by artist in 1856
D09218-481, D40579-81, D40583, D41231 / CXXXI 1

*Devonshire Rivers no. 1 c.*1812-3
9 x 14.2 cm
Tate, Bequeathed by artist in 1856
D09482-667, D40822-8 / CXXXII 1

Devonshire Rivers no. 2 1813
17.8 x 11 cm
Tate, Bequeathed by artist in 1856
D09668-788, D40819-20 / CXXXIII 1

*Devonshire Rivers no. 3 c.*1814
17.9 x 25.4 cm
Tate, Bequeathed by artist in 1856
D09789-855, D09857-88, D40878-84 / CXXXIV 1

Ancillary Material

The Diary of Henry Woollcombe
Plymouth and West Devon Record Office
X12704 / (RO) 710 /394

Henry Woollcombe Letter
Plymouth and West Devon Record Office
X12705 / (RO) 710 /520

JMW Turner Letter 1815
Plymouth and West Devon Record Office
X14133 / (RO) 710 /494

Acknowledgments

This catalogue has been published
to accompany the exhibition
Light into Colour *Turner in the South West*

Tate St Ives
28 January – 7 May 2006
Plymouth City Museum and Art Gallery
20 May – 5 August 2006

Texts by Professor Sam Smiles
and David Blayney Brown

ISBN-10 1 85437 632 2
ISBN-13 978 185437 632 9
LOC 2005937954

A catalogue record for this publication
is available from the British Library
© Tate Trustees 2006 all rights reserved
All works courtesy of credited lenders
Images © Tate (unless otherwise credited)

Edited by Sara Hughes, Susan Daniel-McElroy,
Kerry Rice and Arwen Fitch
Design by Andrew Smith
Repro and print by Jigsaw, Leeds

This exhibition has been organised in partnership
with Plymouth City Museum and Art Gallery.
The exhibition has been supported by
Tate St Ives' Members and Tate Members.

TATE Plymouth City
&museums
artgallery

Front cover
Plymouth* (detail)
*c.*1825
Watercolour
16 x 24.5 cm
Courtesy Calouste Gulbenkian
Museum, Lisbon
Photo: Margarida Ramalho